Make Trouble

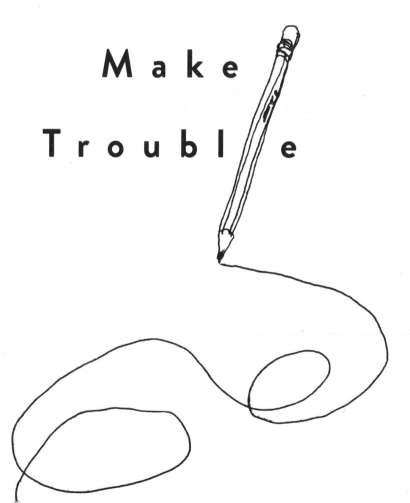

Make Trouble

John Waters

Illustrated by Eric Hanson

ALGONQUIN BOOKS OF CHAPEL HILL 2017

Published by
ALGONQUIN BOOKS OF CHAPEL HILL
Post Office Box 2225
Chapel Hill, North Carolina 27515-2225

a division of
WORKMAN PUBLISHING
225 Varick Street
New York, New York 10014

Grunge art, pages 34–35 © Thoth Adan, istockphoto.com
Author photo © Stephen Maturen, Illustrations © Eric Hanson,
Art direction and design by Anne C. Winslow

Library of Congress Cataloging-in-Publication Data

Names: Waters, John, 1946– | Rhode Island School of Design.
Title: Make trouble / by John Waters.
Description: First edition. | Chapel Hill, North Carolina : Algonquin Books
of Chapel Hill, 2017. | "Published simultaneously in Canada by Thomas
Allen & Son Limited."
Identifiers: LCCN 2016042924 | ISBN 9781616206352
Subjects: LCSH: Waters, John, 1946– | Motion picture producers and
directors—United States—Biography. | Creative ability. | Creation
(Literary, artistic, etc.) | College orations—Rhode Island School of Design.
Classification: LCC PN1998.3.W38 A3 2017 | DDC 791.4302/33092 [B] —dc23
LC record available at https://lccn.loc.gov/2016042924

10 9 8 7 6 5 4 3 2 1

First Edition

Make Trouble

John Waters

was invited to address

a recent graduating class

of the

Rhode Island School of Design.

This is his speech.

I should say right off that
I am really qualified to be your
commencement speaker.

I was suspended from high school, then kicked out of
college in the first marijuana scandal ever on a university
campus. I've been arrested several times.

I've been known
to dress in ludicrous
fashions. I've also
built a career out of
negative reviews,
and have been called
the Prince of Puke
by the press.

And most recently a title I'm really proud of:

The People's
Pervert

I am honored
to be here today
with my people.

Okay,

I'M SUPPOSED TO INSPIRE YOU.

HOW'S THIS?

Somehow I've been able to
make a living doing what I love best
for fifty years without ever having
to get a real job.

"But how can you be so disciplined?" friends always ask when I tell them my job is to get up every day at 6 a.m. Monday to Friday and think up insane stuff.

Easy! If I didn't work
this hard for myself,
I'd have to go work
for somebody else.
Plus, I can go to my
office one room away
from my bedroom
in my own house
dressed in my
underpants
if I want to.

You're lucky.

When I went to school,
my teachers discouraged
every dream I ever had.
I wanted to be the filthiest
person alive, but no school
would let me. Today, you
could possibly even make
a snuff movie in college
and get an A+.

Hopefully you have been taught
never to fear rejection in the workplace.

Remember, a "no" is free.

Ask for the world and pay no mind

if you are initially turned down.

A career in the arts is like a
hitchhiking trip: All you need
is one person to say "get in,"
and off you go.

THERE

HERE

And then the confidence begins.

Of course,
play is equally
as important to
your education
as work.

And in the fine arts, play *is* work, isn't it?

What other field allows you to deduct as business expenses from your taxes gangsta rap, Gaspar Noé's movies, even vintage porn as long as you use it for research?

REMEMBER: you must participate in the creative world you want to become part of.

SO WHAT IF YOU HAVE TALENT?

THEN WHAT?

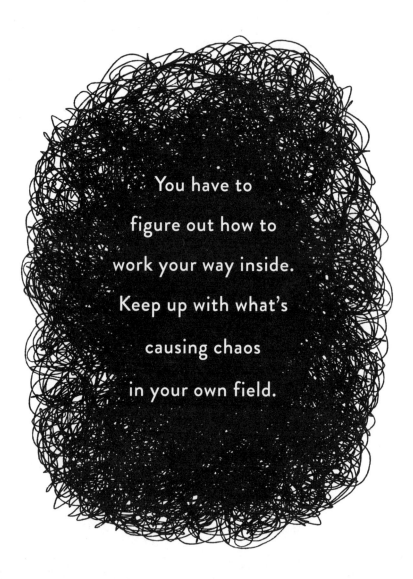

You have to

figure out how to

work your way inside.

Keep up with what's

causing chaos

in your own field.

If you're a visual artist, go see the shows in the galleries that are frantically competing to find the one bad neighborhood left in Manhattan to open up in.

Watch every movie that gets a negative review in the *New York Times* and figure out what the director did wrong. Or right!

Read, read, read!

Watch people on the streets.

SPY,

BE NOSY,

EAVESDROP.

nd, as you get older, you'll need youth spies that will keep you abreast of new music that nobody your age has heard of yet or body-piercing mutilations that are becoming all the rage—even budding sexually transmitted diseases you should go to any length to avoid.

ever be like some of my generation who say, "We had more fun in the sixties." No, we didn't! The kids today who still live with their parents (who haven't seen them in months but leave food outside their bedroom doors) are having just as much fun shutting down the governments of foreign countries on their computer as we did banning the bomb.

Today may be the end of

your juvenile delinquency,

but it should also be the

first day of your new adult

disobedience.

THESE DAYS,
EVERYBODY WANTS
TO BE

AN OUTSIDER,

POLITICALLY CORRECT
TO A FAULT.

hat's good. I hope you *are* working to end racism, sexism, ageism, fatism. But is that enough? Isn't being an outsider sooo last year? I mean, maybe it's time to throw caution to the wind, *really* shake things up, and reinvent yourself as a new version of your most dreaded enemy:

Like I am.

The final irony—
a creatively crazy person
who finally gets power.

**Think about it:
I didn't change.
Society did.**

Who would have
ever thought a top
college would invite
a filth elder like myself
to set an example
to its students?

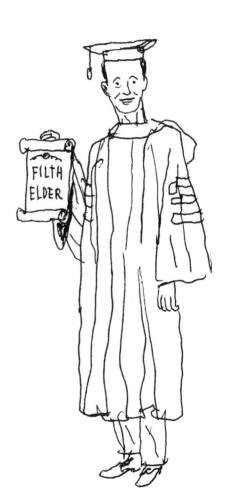

See? There's hope for everybody.

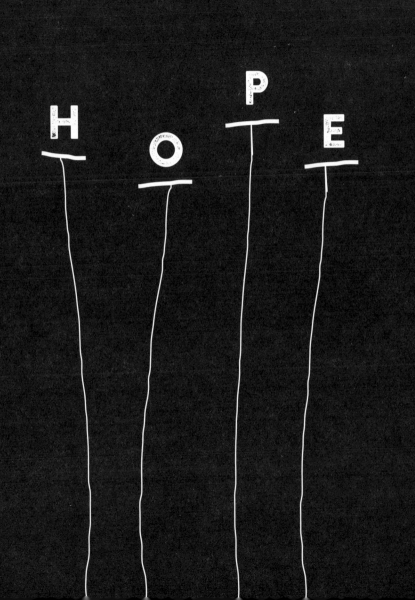

You need
to prepare
sneak attacks
on society.

Hairspray is the only really devious movie
I ever made. The musical based on it is now being
performed in practically every high school in
America—and nobody seems to notice it's a show
with two men singing a love song to each other that
also encourages white teen girls to date black guys.
Pink Flamingos was preaching to the converted.

But *Hairspray* is a Trojan horse: it snuck into
Middle America and never got caught.
You can do the same thing.

Listen to your political enemies, especially the smart ones, and then figure out a way to make them laugh.

SPEECH
ALARM

Nobody likes a bore on a soapbox.

Humor is always the best defense *and* weapon. If you can make an idiot laugh, they'll at least pause and listen before they do something stupid . . . to you.

Refuse to isolate yourself. Separatism is for losers.

Gay is not enough anymore. It's a good start, but I don't want my memoirs to be in the gay section near true crime at the back of the bookstore next to the bathrooms. No! I want it up front with the best sellers. And don't heterosexual kids actually receive more prejudice in art schools today than the gay ones? Things are a-changing. It's a confusing time.

TRIGGER

||

This might be time for a trigger warning—
the amazing concept I've heard about in which
you're supposed to warn students if you're
going to talk about something that challenges
their values. I thought that's why you *went*
to college. My whole life has been a trigger
warning. But you have been warned. So the
trigger warning is in effect, and now back to
the prepared speech.

||

WARNING

Don't hate all rich people. They're not all awful.

Believe me, I know some evil poor people, too.

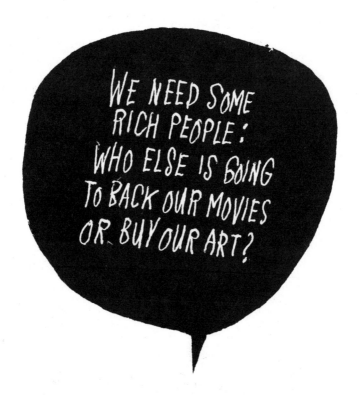

AND NOT BEING AROUND ASSHOLES SHOULD BE THE GOAL OF EVERY GRADUATE HERE TODAY.

I'm rich! I don't mean money-wise. I mean that I have figured out how to never be around assholes at any time in my personal and professional life. That's rich.

It's okay to hate the poor, too,
but only the poor of spirit,
not wealth.

A poor person to me can
have a big bank balance,
but is uncurious, judgmental,
isolated, and unavailable
to change.

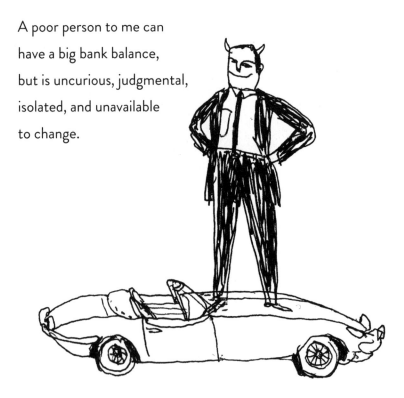

I'm also sorry
to report there's
no such thing
as karma.

So many of my talented,
great friends are dead
and so many of the fools
I've met and loathed are
still alive. It's not fair,
and it never will be.

Parents, now it's time
to talk to you.

od, these kids can be brats, can't they? Entitled little bastards. Do they think you're made of money?

Can't they give you a second to adjust to such social changes as sexual reassignment surgery, horn implants, and the political rights of the adult-baby community?

AND, YOUNG ADULTS,

MAYBE TODAY IS THE DAY YOU

BLAMING YOUR PARENTS

FOR EVERY PROBLEM YOU'VE

EVER HAD.

Whining is never appealing in a college graduate.

Yes, it's a drag you were kept locked in a cardboard box
under their bed and whipped daily with a car aerial,
but it's time to move on. We've all been dealt a hand.
Deal with it!

And, parents, vice versa:
You don't get to order up your kids,
either.

Maybe your daughter did tattoo
her entire face.
Well, work with what you got!
Think positively:
maybe she'll open a fancy tattoo
parlor in Paris.

I'm touched to sometimes see distraught parents bringing their angry and defiant teenage children with them to see my spoken-word show in a last-ditch effort to bond. At least both sides are trying.

The truce
of maturity will
come to families
if every member
is patient.

I often look back in wonder
at how understanding
my parents were. Dr. Spock
didn't have a chapter in his
child-rearing book on how
to handle your son if all
he wanted to do as a child
was play "car accident." Yet my mom took me to junkyards
as a toddler and let me wander around fantasizing
ghoulishly.

My dad even lent me the money to make *Pink Flamingos*, and I paid him back in full—with interest. But, looking back, did I really expect him to be thrilled that I had made one of the "most vile, stupid, and repulsive films ever made," as *Variety* called it?

My parents
made me feel safe,
and that's why
I'm up here today.

That's what you should try to do
for your kids, too—no matter *where* you
get your children these days.

CONTEMPORARY ART'S JOB IS TO

WHAT CAME BEFORE.

Is there a better job description than that to aspire to?

Here's another

TRIGGER

WARNING

and pardon me for swearing:

Go out
in the world
and fuck it up
beautifully.

DESIGN

clothes so hideous that they
can't be worn ironically.

HORRIFY

us with new ideas.

OUTRAGE

outdated critics.

USE
TECHNOLOGY

for transgression, not lazy social living.

MAKE ME

NERVOUS!

AND FINALLY,

COUNT YOUR BLESSINGS.

You got through college. You didn't commit suicide,
OD, or have a nervous breakdown, and let's remember
the ones who did.

IT'S TIME TO

get
busy.

It's

your

turn

to

make

trouble.

BUT THIS TIME
IN THE REAL WORLD.
AND THIS TIME FROM
THE INSIDE.

Thank you very much.

JOHN WATERS is a filmmaker, writer, actor, and visual artist best known for the films *Pink Flamingos*, *Serial Mom*, and *Hairspray*, which was adapted into a long-running Broadway musical. The author of seven books, among them the *New York Times* bestsellers *Carsick* and *Role Models*, he performs his one-man, spoken-word shows regularly in the United States and abroad. Waters lives in Baltimore, Maryland. Please visit maketrouble.com for more information.